QUENTIN TARANTINO

A Graphic Biography

Quarto

First published in 2024 by Frances Lincoln,
an imprint of The Quarto Group.
One Triptych Place, London, SE1 9SH,
United Kingdom
T (0)20 7700 9000
www.Quarto.com

A catalogue record for this book is available from the British Library.

ISBN 978-0-7112-9076-1
Ebook ISBN 978-0-7112-9077-8

10 9 8 7 6 5 4 3 2 1

Publisher: Philip Cooper
Commissioning Editor: John Parton
Senior Editor: Laura Bulbeck
Senior Designer: Renata Latipova
Production Controller: Rohana Yusof

Printed in China

Disclaimer: This publication and its contents are not licensed,
authorised or connected with Quentin Tarantino or his work.
This publication includes elements of Quentin Tarantino's life,
and that of others, which have been fictionalised.

QUENTIN TARANTINO

A Graphic Biography

Text by
Michele Botton

Illustrations by
Bernardo Santiago Acosta

Translation by
Edward Fortes

Edited by
Balthazar Pagani

FRANCES
LINCOLN

CHAPTER ONE

ONE MINUTE
YOU'RE A DANCER,
THE NEXT
YOU'RE A GANGSTER

IN WHICH TARANTINO CONVINCES JOHN TRAVOLTA TO BE IN *PULP FICTION*,
GETS LOST IN REMINISCING, AND TALKS ABOUT HIS CHILDHOOD AND
TEENAGE YEARS. AND WE LEARN ABOUT HOW AUTHOR ELMORE LEONARD
INFLUENCED HIS WORK.

13 41

CHAPTER TWO

THE BLONDE
WITH THE CUTE FEET
WHO BECAME
A BLOODTHIRSTY BRIDE

IN WHICH, DURING THE MAKING OF *PULP FICTION*, TARANTINO GETS WRAPPED UP IN
CONVERSATION WITH UMA THURMAN AS THEY PLAN THEIR NEXT MOVIE TOGETHER
AND TELLS HER OF HIS ADVENTURES WHILE WORKING AS A VIDEO-STORE CLERK.

CHAPTER THREE

THE PEN BEHIND THE CAMERA AND THE MAN HOLDING THE PEN

IN WHICH TARANTINO HAS A FEW DRINKS WITH FELLOW DIRECTOR ROBERT RODRIGUEZ AND THEY END UP TALKING ABOUT TARANTINO'S PASSION FOR WRITING, A PASSION THAT MIGHT BE LESS IN-YOUR-FACE THAN HIS DIRECTING, BUT NO LESS SUCCESSFUL.

69 **99**

CHAPTER FOUR

BRASH HOLLYWOOD HEAVYWEIGHTS CHANGE HISTORY

IN WHICH A TRIO OF STARS – QUENTIN TARANTINO, BRAD PITT AND LEONARDO DICAPRIO – DISCUSS OUR FAVOURITE DIRECTOR'S MOVIES AND HIS VIEW OF VIOLENCE ON SCREEN.

QUENTIN TARANTINO
A great director's journey

EZEKIEL 25:17

WHY QUENTIN TARANTINO? ISN'T IT ENOUGH THAT HE'S ONE OF HIS GENERATION'S MOST INFLUENTIAL AND SUCCESSFUL DIRECTORS? THAT HE'S RACKED UP HUGE AMOUNTS OF AWARDS, INCLUDING TWO OSCARS? DON'T HIS FILMS TELL US ENOUGH ABOUT HIM?

Well – no, none of that is enough. His story is worth telling because it's the story of someone who goes on to achieve SOMETHING EXTRAORDINARY, after appearing destined for a very ordinary life. A man driven by such a passion for cinema, who channels that passion so forcefully, that he ends up rewriting the rules of filmmaking itself – THAT'S QUENTIN TARANTINO.

Tarantino gorged himself on cinema from an early age, and he did more than simply watch films. He enjoyed them, of course, but at the same time he always tried

to look beyond the screen, at what lay behind it: how the story was constructed, how the characters were built, what the shots were doing.

HE THOUGHT ABOUT IT TECHNICALLY AND CRITICALLY, MAKING ITS STRENGTHS HIS OWN AND RECOGNISING ANY POSSIBLE WEAKNESSES.

From there he emerged as ONE OF CONTEMPORARY CINEMA'S GREATEST SCREENWRITERS AND DIRECTORS. Equipped with first-rate technical abilities, as well as the distinctive style that makes his work so recognizable, Tarantino also has another strength that gives him an edge, one not to be underestimated: HE MAKES THE FILMS HE WANTS TO MAKE – with shootouts, lots of blood, catchy dialogue, cool characters, epic scenes and grotesque situations. People in the industry may love or hate him, but they rarely remain indifferent. The reason for this, above and beyond anything else, is that Tarantino's work is full of heart and passion.

This graphic biography brings you his life story, retold in a style that alludes to his own, and in that sense my choice is a specific homage to a master of storytelling. First of all, I've mixed up the chapters so they're not in chronological order. By the time you get to the end, this moving back-and-forth in time offers you a complete view of the character. I show his childhood and teenage years, as well as his life as

a young man before breaking into the film world. HE'S A STRONG-MINDED AND PRICKLY CHARACTER, but at the same time he's ambitious and pragmatic, full of inspiration, never ordinary.

THROUGHOUT HIS CAREER HIS WORK HAS SPANNED A VARIETY OF GENRES, BUT HE'S ALWAYS STAYED TRUE TO HIMSELF.

In the story, you'll see him interact with some of the famous people who have worked with him: **UMA THURMAN** (*Pulp Fiction*, *Kill Bill*), **BRAD PITT** (*Inglourious Basterds*, *Once Upon a Time in Hollywood*), **LEONARDO DICAPRIO** (*Django Unchained*, *Once Upon a Time in Hollywood*), **JOHN TRAVOLTA** (*Pulp Fiction*), **PAM GRIER** (*Jackie Brown*) and **ROBERT RODRIGUEZ** (*Grindhouse*: *Planet Terror*, *From Dusk till Dawn*).

Through a series of exchanges with these characters – serious at times, irreverent at others – I reveal some of Tarantino's thoughts about cinema: his tastes, the role violence plays in his films, his status as a cult director and his relationship to writing. Writing really has a major significance in Quentin Tarantino's life – all the more so recently, since he started writing novels.

He's an , as well as a director – and an excellent screenwriter, twice winner of the Oscar for Best Original Screenplay (for *Pulp Fiction* and *Django Unchained*). The famous branding that appears at the beginning of his films, 'Written and Directed by Quentin Tarantino,' isn't just a marketing ploy.

PERHAPS NO FILMMAKER HAS EVER MANAGED TO MASTER AND EXCEL IN TWO DOMAINS THE WAY QUENTIN TARANTINO HAS, NO MATTER HOW INTERTWINED THE TWO MAY BE.

BUT I NEEDN'T GO ON ANY LONGER: SIT BACK AND ENJOY THIS GRAPHIC NOVEL.

Michele Botton

THE BLONDE WITH THE CUTE FEET WHO BECAME A BLOODTHIRSTY BRIDE

IN WHICH, DURING THE MAKING OF *PULP FICTION*, TARANTINO GETS WRAPPED UP IN
CONVERSATION WITH UMA THURMAN AS THEY PLAN THEIR NEXT MOVIE TOGETHER AND TELLS
HER OF HIS ADVENTURES WHILE WORKING AS A VIDEO-STORE CLERK.

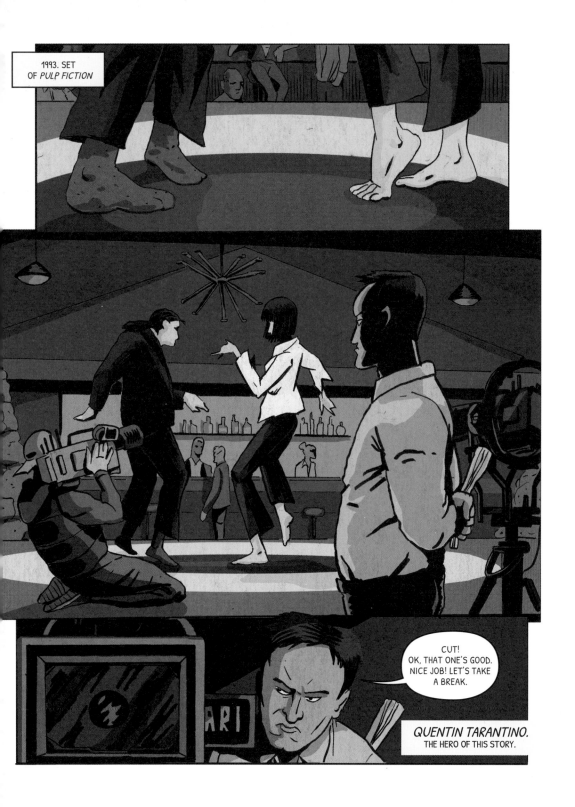

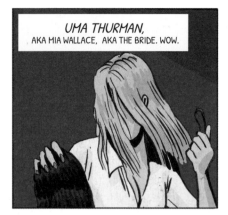

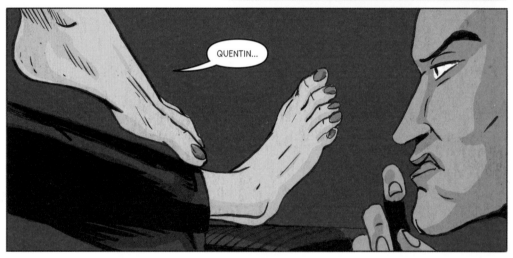

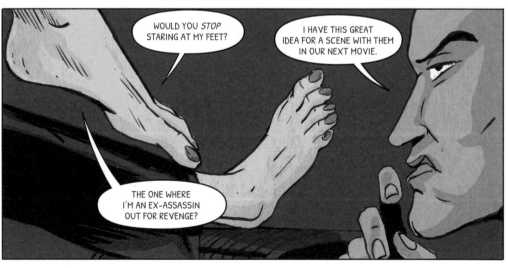

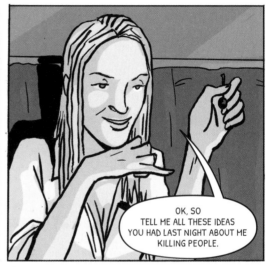

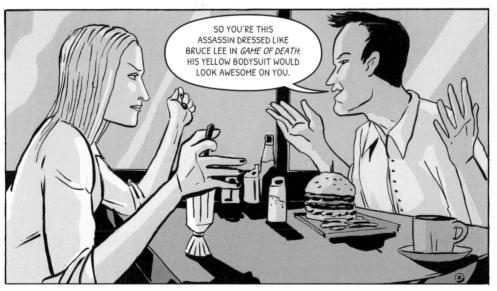

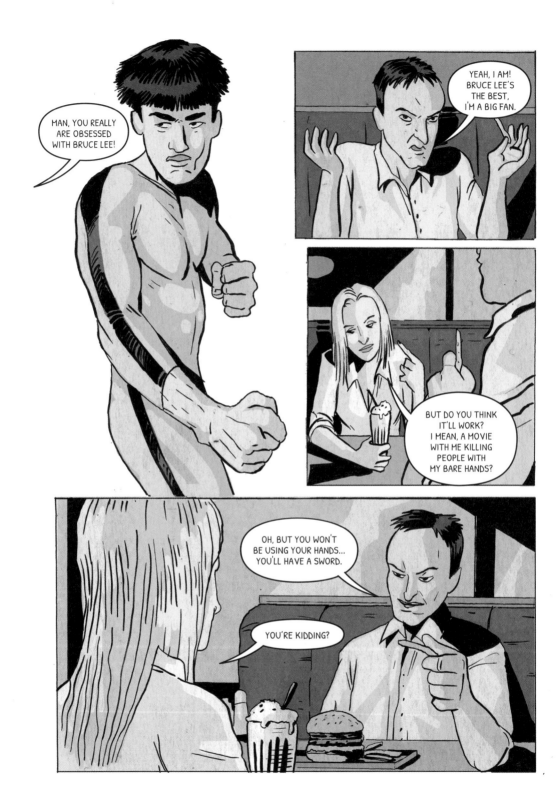

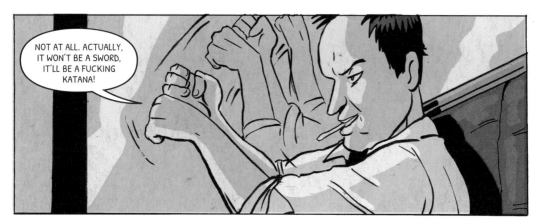

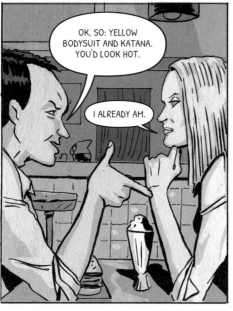

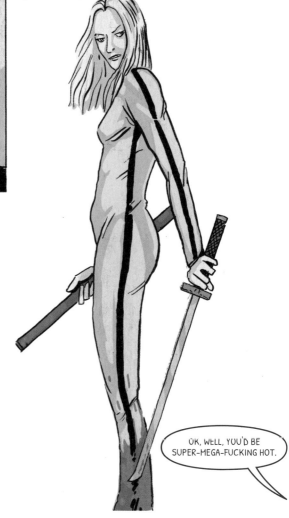

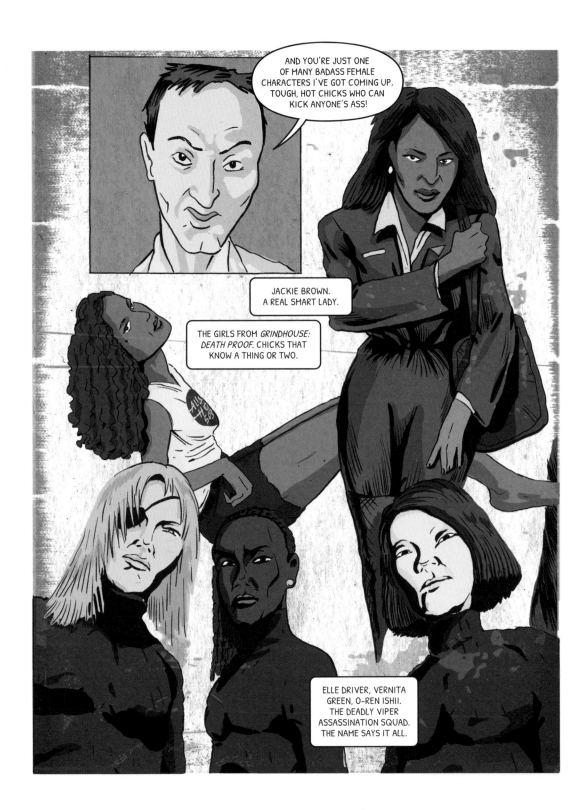

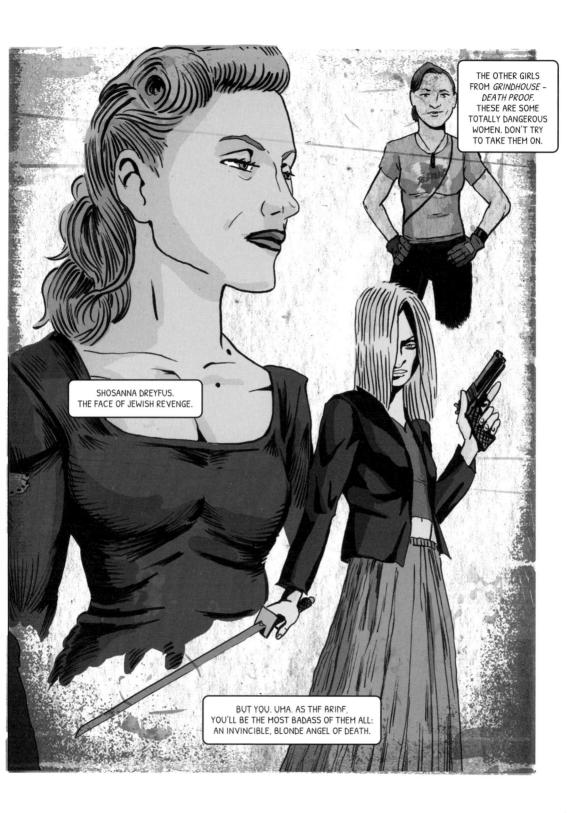

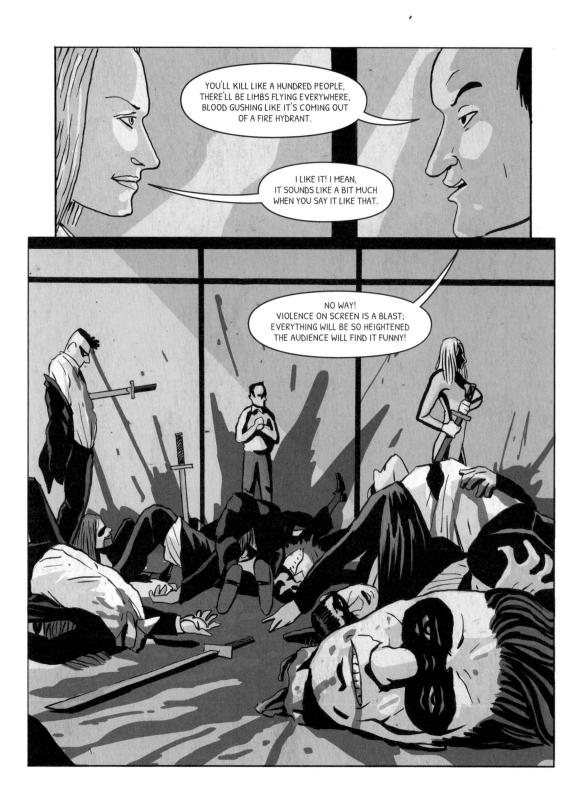

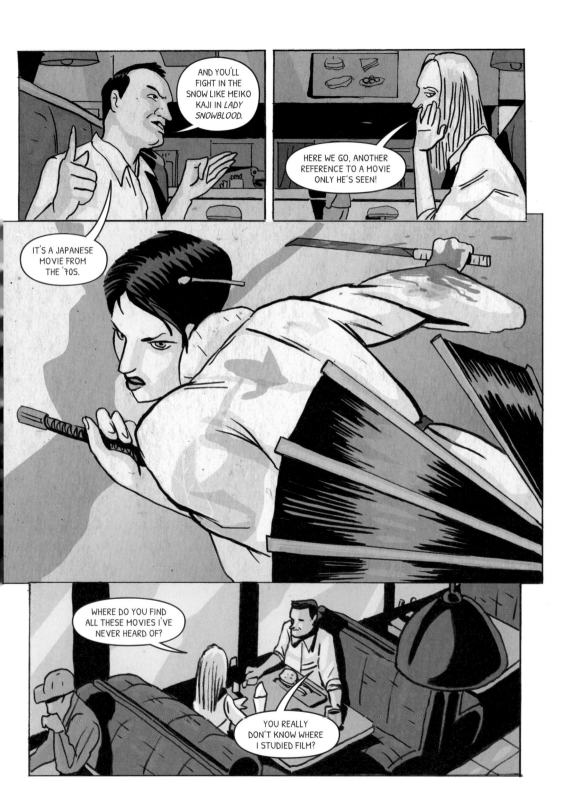

23

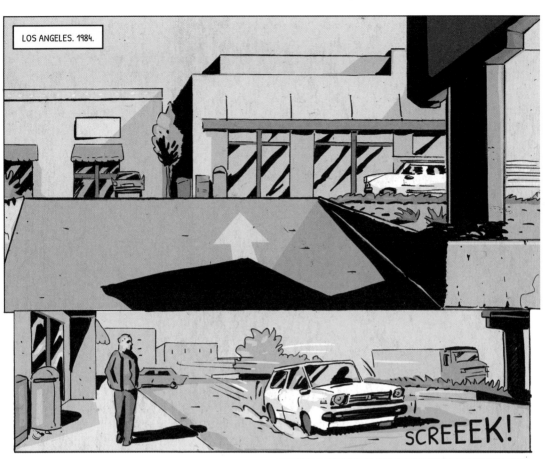

LOS ANGELES. 1984.

SCREEEK!

FUCK!

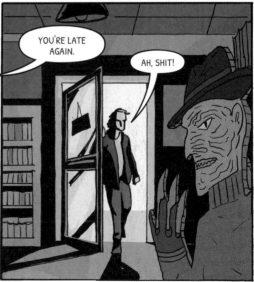

YOU'RE LATE AGAIN.

AH, SHIT!

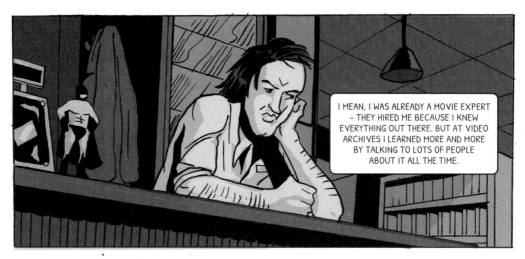

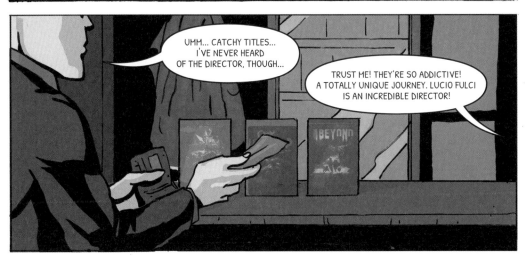

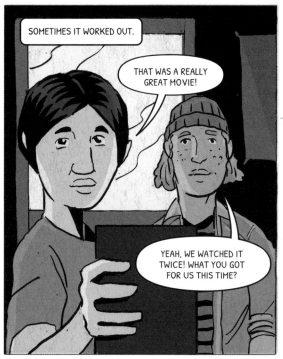

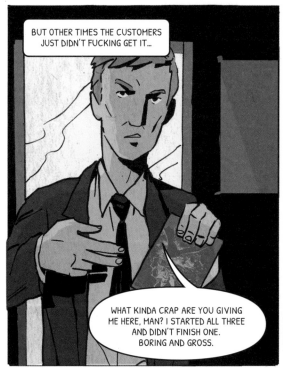

OBVIOUSLY, WHEN IT WAS QUIET, I WATCHED MOVIE AFTER MOVIE.

AND WHEN I FINISHED MY SHIFT I'D TAKE A COUPLE HOME AND DEVOUR THEM.

I LIVED AND BREATHED CINEMA FROM MORNING TILL NIGHT.

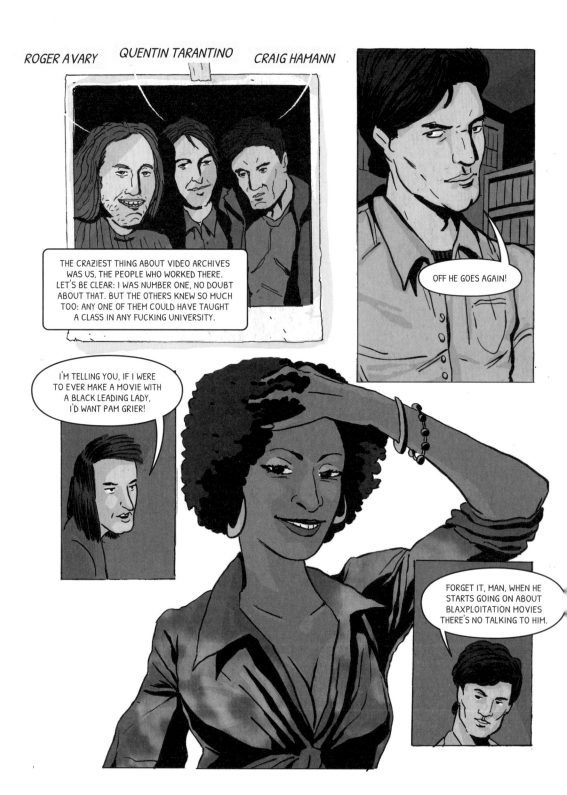

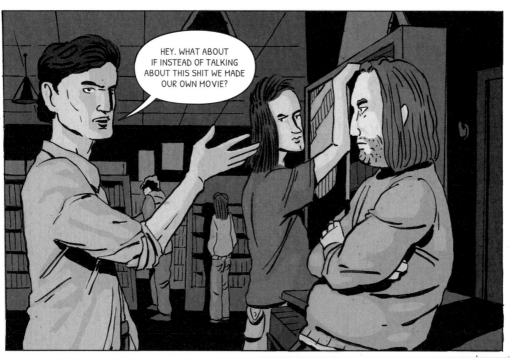

IN THE END WE RAISED MORE THAN $5,000.

THE END PRODUCT WAS *MY BEST FRIEND'S BIRTHDAY*. WE SHOT IT IN 1987.

IT WAS A HUGE MESS. TOTALLY EXHAUSTING AND INCONCLUSIVE.

WE HAD TO MANAGE EVERYTHING: WRITING, PRODUCING, DIRECTING AND EDITING, DO ALL THE SETS...

AND WE ACTED IN IT TOO. ALL OF OUR ENERGIES WENT INTO THESE THOUSANDS OF TASKS.

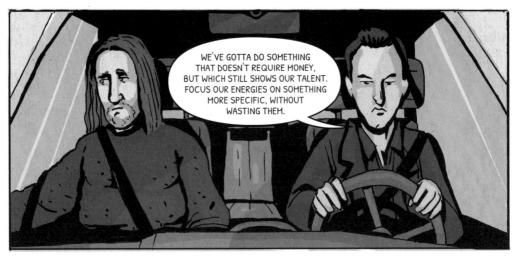

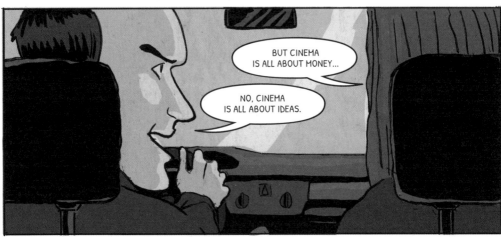

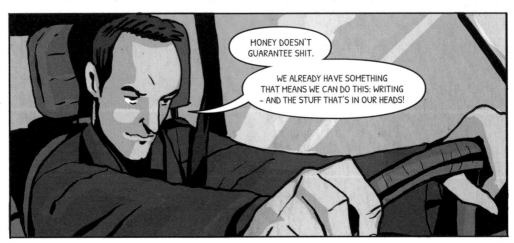

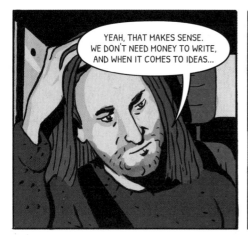

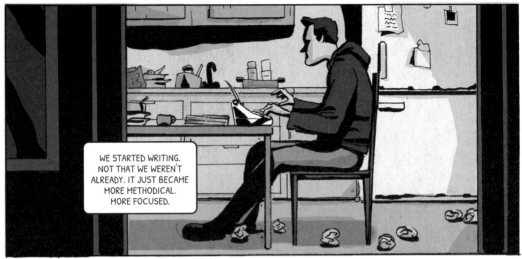

WE STARTED WRITING.
NOT THAT WE WEREN'T
ALREADY. IT JUST BECAME
MORE METHODICAL.
MORE FOCUSED.

HERE YOU GO, TAKE A LOOK:
I WORKED ON THE DIALOGUE
LAST NIGHT.

GREAT, I LEFT YOU
SOME NOTES ON THE SHOOTOUT
SCENE ON THE COUNTER.
I ADDED A COUPLE OF SHOTS
TO MAKE EVERYTHING
A BIT SMOOTHER.

I THINK WE'RE READY.

ROGER AVARY.
TARANTINO'S CO-WRITER
ON *TRUE ROMANCE*,
AND THE MAN WITH
WHOM HE SHARED
THE OSCAR FOR BEST
ORIGINAL SCREENPLAY
FOR *PULP FICTION*.

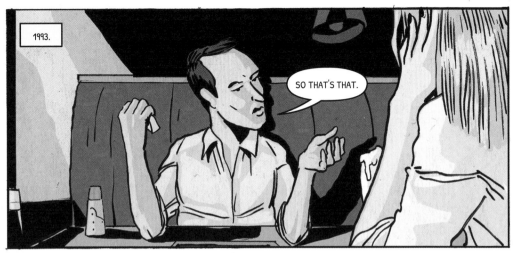

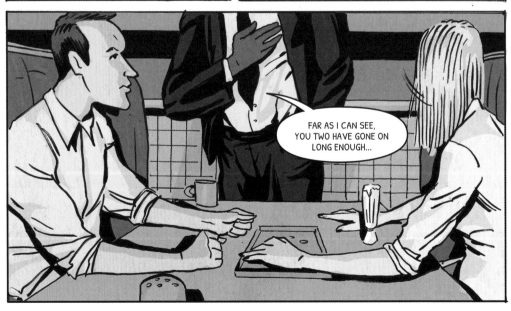

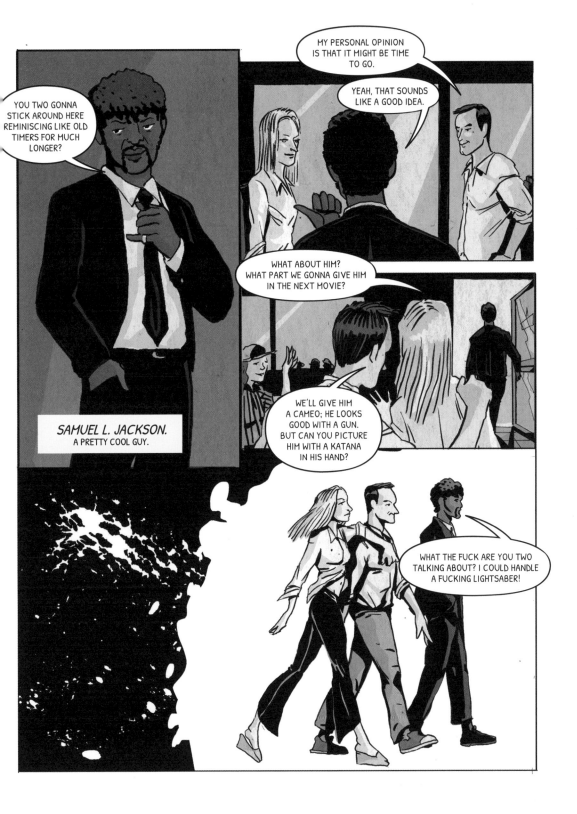

BRASH HOLLYWOOD HEAVYWEIGHTS CHANGE HISTORY

IN WHICH A TRIO OF STARS – QUENTIN TARANTINO, BRAD PITT AND
LEONARDO DICAPRIO – DISCUSS OUR FAVOURITE DIRECTOR'S MOVIES
AND HIS VIEW OF VIOLENCE ON SCREEN.

BUT WHAT MATTERS – WHAT *REALLY* MATTERS – IS SOMETHING ELSE.

LOS ANGELES, 2018.

CASA VEGA

LET'S TRY TO NOT STUFF OUR FACES THIS TIME, LIKE WE ALWAYS DO.

YOU'RE THE ONE WHO'S ALWAYS STUFFING YOUR FACE.

EXACTLY!

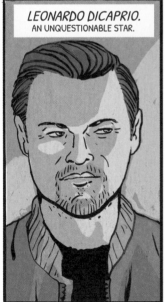

LEONARDO DICAPRIO.
AN UNQUESTIONABLE STAR.

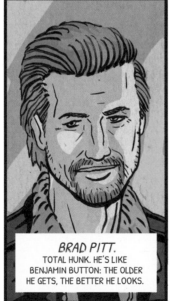

BRAD PITT.
TOTAL HUNK. HE'S LIKE BENJAMIN BUTTON: THE OLDER HE GETS, THE BETTER HE LOOKS.

QUENTIN TARANTINO.
CULT DIRECTOR.

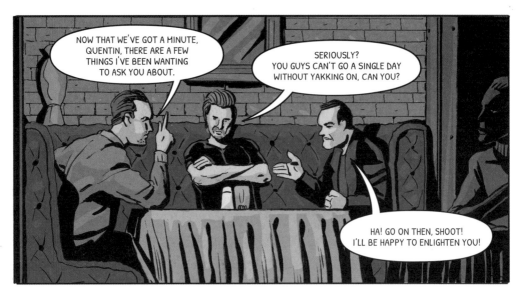

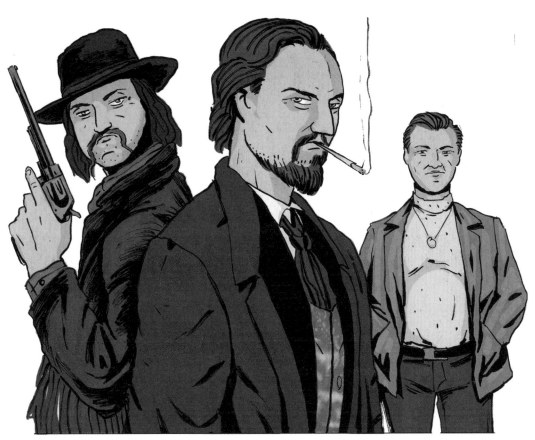

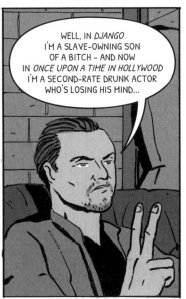

WELL, IN *DJANGO* I'M A SLAVE-OWNING SON OF A BITCH — AND NOW IN *ONCE UPON A TIME IN HOLLYWOOD* I'M A SECOND-RATE DRUNK ACTOR WHO'S LOSING HIS MIND...

THOSE ARE FIRST-CLASS CHALLENGES FOR AN ACTOR. YOU'VE MADE THESE CHARACTERS CREDIBLE AND CHARISMATIC, THAT COUNTS FOR A LOT.

THAT'S TRUE. PARTICULARLY WITH THAT LAUGH, THE ONE THAT TURNED INTO AN ONLINE MEME.

I IMAGINE THE CRITICS WOULD SPLIT MY WORK INTO THREE MAIN CATEGORIES. THE FIRST WOULD INCLUDE THE MOST VIOLENT MOVIES.

RESERVOIR DOGS

PULP FICTION...

KILL BILL...

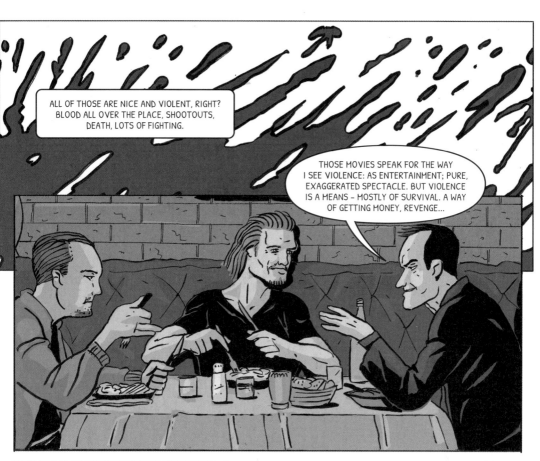

ALL OF THOSE ARE NICE AND VIOLENT, RIGHT? BLOOD ALL OVER THE PLACE, SHOOTOUTS, DEATH, LOTS OF FIGHTING.

THOSE MOVIES SPEAK FOR THE WAY I SEE VIOLENCE: AS ENTERTAINMENT; PURE, EXAGGERATED SPECTACLE. BUT VIOLENCE IS A MEANS – MOSTLY OF SURVIVAL. A WAY OF GETTING MONEY, REVENGE...

... WHICH ARE PLAUSIBLE HUMAN MOTIVATIONS. ANYWAY, THE EVENTS OF THE STORY COULD EASILY HAVE HAPPENED SOMEWHERE IN OUR WORLD, RIGHT?

AS EXAGGERATED AS THEY ARE, I'D SAY THEY COULD. BUT WHERE ARE YOU GOING WITH THIS?

IF YOU HOLD ON FOR JUST A SECOND, I'LL TELL YOU...

THEN WE'VE GOT THE THREE 'HOMAGES', LET'S CALL THEM THAT, TO MOVIES I'VE ALWAYS LOVED...

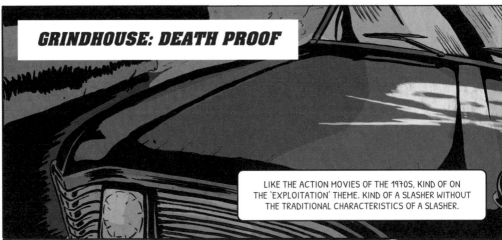

GRINDHOUSE: DEATH PROOF

LIKE THE ACTION MOVIES OF THE 1970S, KIND OF ON THE 'EXPLOITATION' THEME. KIND OF A SLASHER WITHOUT THE TRADITIONAL CHARACTERISTICS OF A SLASHER.

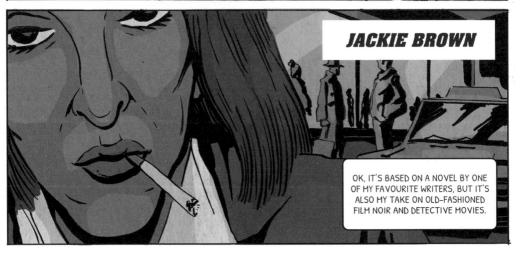

JACKIE BROWN

OK, IT'S BASED ON A NOVEL BY ONE OF MY FAVOURITE WRITERS, BUT IT'S ALSO MY TAKE ON OLD-FASHIONED FILM NOIR AND DETECTIVE MOVIES.

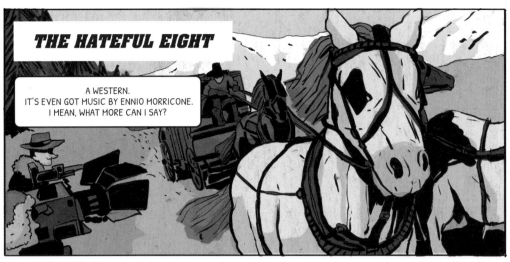

THE HATEFUL EIGHT

A WESTERN.
IT'S EVEN GOT MUSIC BY ENNIO MORRICONE.
I MEAN, WHAT MORE CAN I SAY?

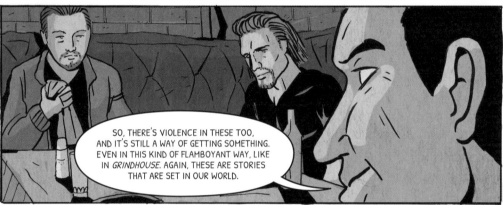

SO, THERE'S VIOLENCE IN THESE TOO,
AND IT'S STILL A WAY OF GETTING SOMETHING.
EVEN IN THIS KIND OF FLAMBOYANT WAY, LIKE
IN *GRINDHOUSE*. AGAIN, THESE ARE STORIES
THAT ARE SET IN OUR WORLD.

WAIT A SECOND.
WHAT ABOUT
DJANGO UNCHAINED?
ISN'T THAT AN HOMAGE
TO THE WESTERN TOO?

OF COURSE, BUT
DJANGO UNCHAINED
ISN'T SET IN OUR WORLD...

WHAT THE FUCK ARE YOU TALKING ABOUT?

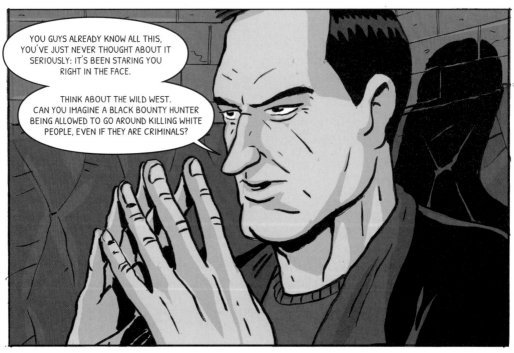

YOU GUYS ALREADY KNOW ALL THIS, YOU'VE JUST NEVER THOUGHT ABOUT IT SERIOUSLY: IT'S BEEN STARING YOU RIGHT IN THE FACE.

THINK ABOUT THE WILD WEST. CAN YOU IMAGINE A BLACK BOUNTY HUNTER BEING ALLOWED TO GO AROUND KILLING WHITE PEOPLE, EVEN IF THEY ARE CRIMINALS?

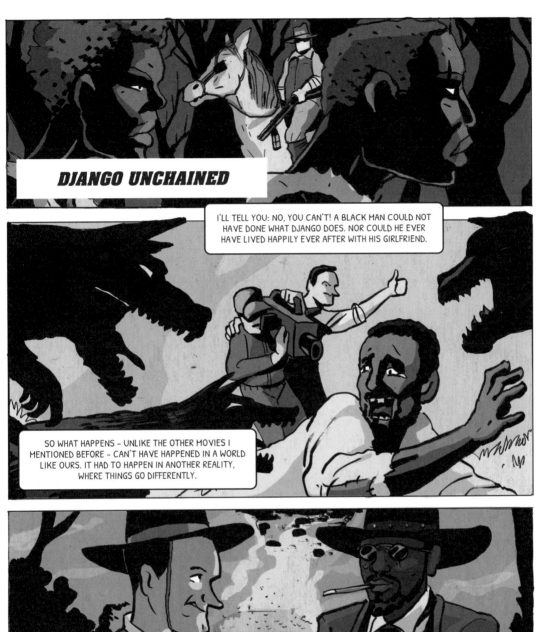

DJANGO UNCHAINED

I'LL TELL YOU: NO, YOU CAN'T! A BLACK MAN COULD NOT HAVE DONE WHAT DJANGO DOES. NOR COULD HE EVER HAVE LIVED HAPPILY EVER AFTER WITH HIS GIRLFRIEND.

SO WHAT HAPPENS - UNLIKE THE OTHER MOVIES I MENTIONED BEFORE - CAN'T HAVE HAPPENED IN A WORLD LIKE OURS. IT HAD TO HAPPEN IN ANOTHER REALITY, WHERE THINGS GO DIFFERENTLY.

SO HERE VIOLENCE ISN'T JUST AN EXPEDIENT TO GAIN YOUR FREEDOM OR GET REVENGE: IT GIVES US A WAY OF TRANSFORMING REALITY INTO SOMETHING THAT OTHERWISE COULDN'T EXIST. TO REWRITE HISTORY.

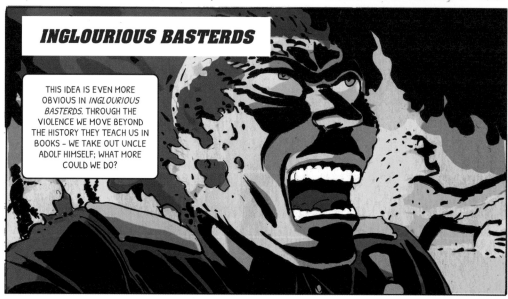

INGLOURIOUS BASTERDS

THIS IDEA IS EVEN MORE OBVIOUS IN *INGLOURIOUS BASTERDS*. THROUGH THE VIOLENCE WE MOVE BEYOND THE HISTORY THEY TEACH US IN BOOKS – WE TAKE OUT UNCLE ADOLF HIMSELF; WHAT MORE COULD WE DO?

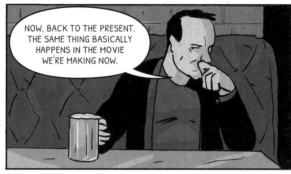

NOW, BACK TO THE PRESENT. THE SAME THING BASICALLY HAPPENS IN THE MOVIE WE'RE MAKING NOW.

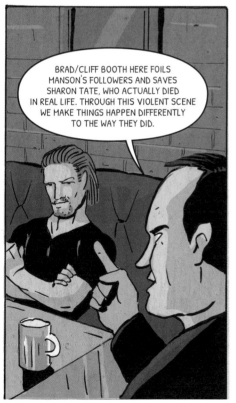

BRAD/CLIFF BOOTH HERE FOILS MANSON'S FOLLOWERS AND SAVES SHARON TATE, WHO ACTUALLY DIED IN REAL LIFE. THROUGH THIS VIOLENT SCENE WE MAKE THINGS HAPPEN DIFFERENTLY TO THE WAY THEY DID.

I GET THAT. I GET THAT AND I RESPECT IT. THAT'S ALL PERFECT.

BUT WE HAVEN'T GOT TO THE MAIN POINT: WHY DOES BUDDY BOY HERE BEAT THE SHIT OUT OF BRUCE LEE?

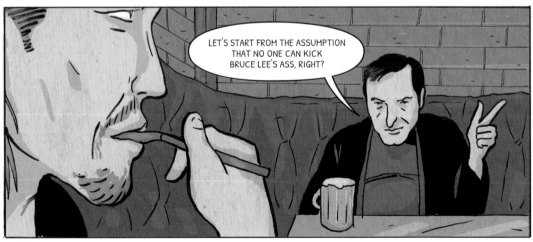

LET'S START FROM THE ASSUMPTION THAT NO ONE CAN KICK BRUCE LEE'S ASS, RIGHT?

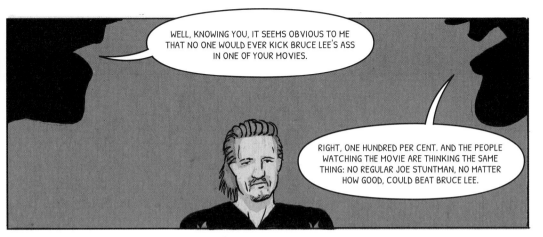

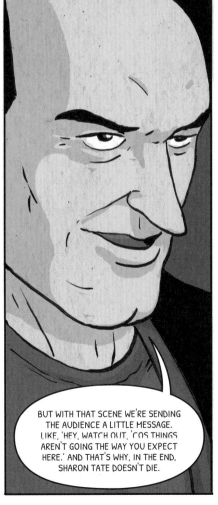

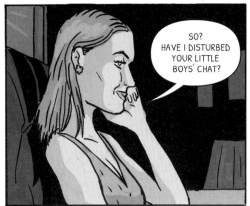

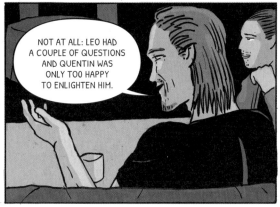

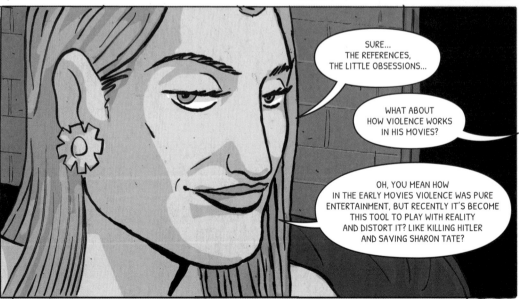

SHE KNOWS A LOT...

ALMOST TOO MUCH...

HAHAHA!

BUT I WOULDN'T WANNA BORE YOU WITH ALL MY CHATTER...

NOT AT ALL! PLEASE GO ON!

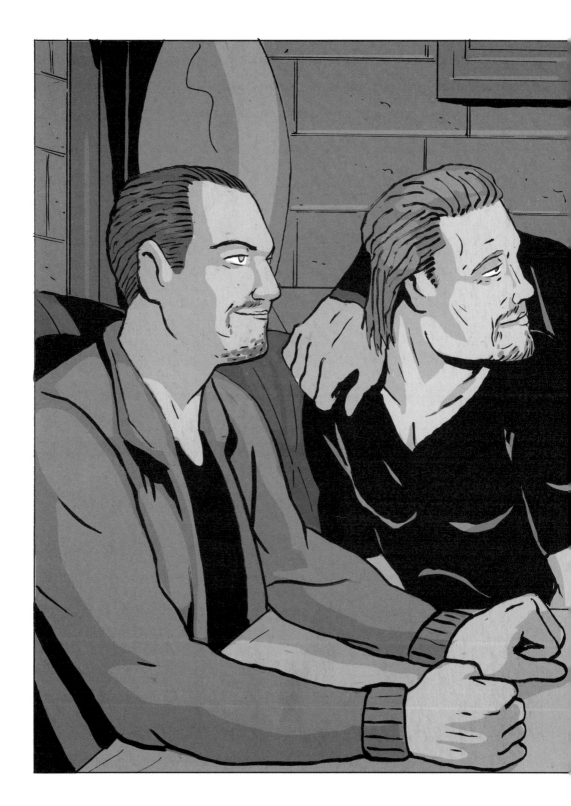

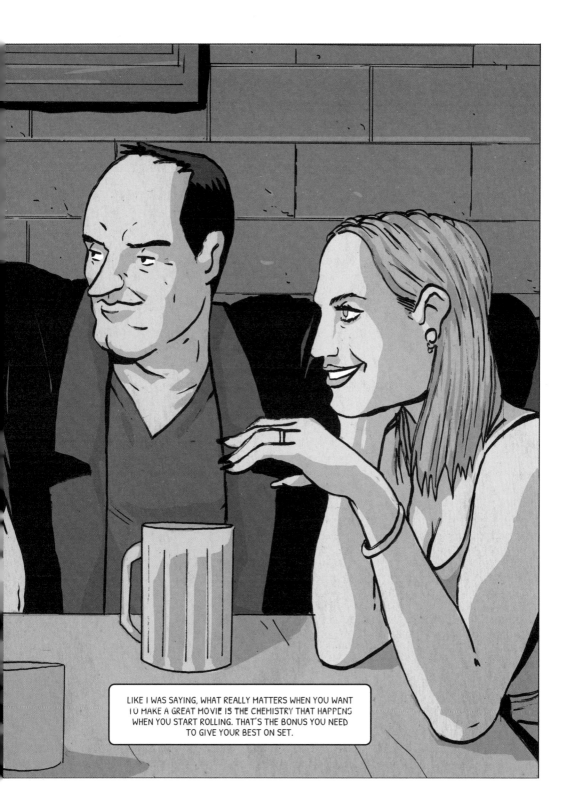

LIKE I WAS SAYING, WHAT REALLY MATTERS WHEN YOU WANT TO MAKE A GREAT MOVIE IS THE CHEMISTRY THAT HAPPENS WHEN YOU START ROLLING. THAT'S THE BONUS YOU NEED TO GIVE YOUR BEST ON SET.

ONE MINUTE
YOU'RE A DANCER,
THE NEXT
YOU'RE A GANGSTER

IN WHICH TARANTINO CONVINCES JOHN TRAVOLTA TO BE IN *PULP FICTION*, GETS LOST IN
REMINISCING, AND TALKS ABOUT HIS CHILDHOOD AND TEENAGE YEARS.
AND WE LEARN ABOUT HOW AUTHOR ELMORE LEONARD INFLUENCED HIS WORK.

1993.

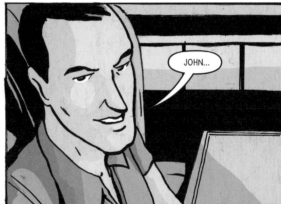

JOHN...

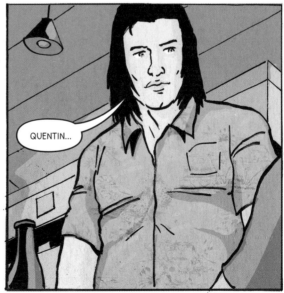

QUENTIN...

JOHN TRAVOLTA.
BEFORE *PULP FICTION* HE WAS
THE 'TONY MANERO' EVERY MOTHER
WANTED TO MARRY THEIR DAUGHTER.
AFTER *PULP FICTION*
HE WAS EVERYONE'S FAVOURITE
LAIDBACK, SLAP-HAPPY GANGSTER.

HI, THERE – WHAT CAN I GET YOU?

A STEAK – RARE – AND A VANILLA COKE.

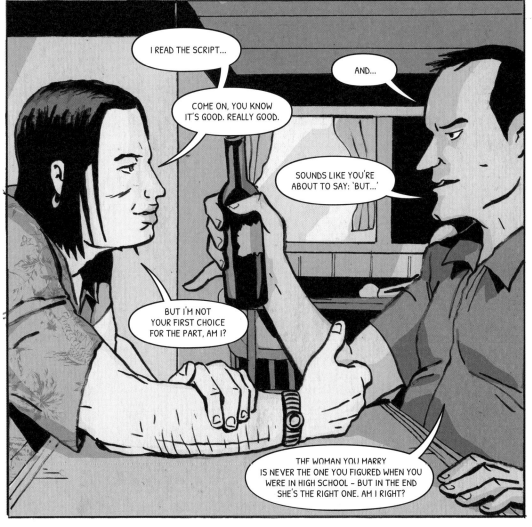

HAHA! YEAH, YOU'RE RIGHT.

BUT THAT'S NOT WHAT'S STOPPING YOU TAKING THE PART. IT'S SOMETHING ELSE...

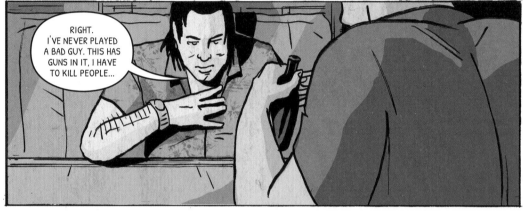

RIGHT. I'VE NEVER PLAYED A BAD GUY. THIS HAS GUNS IN IT, I HAVE TO KILL PEOPLE...

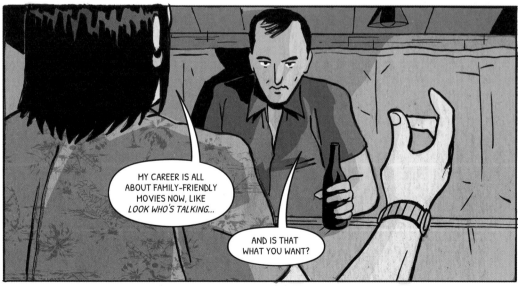

MY CAREER IS ALL ABOUT FAMILY-FRIENDLY MOVIES NOW, LIKE *LOOK WHO'S TALKING*...

AND IS THAT WHAT YOU WANT?

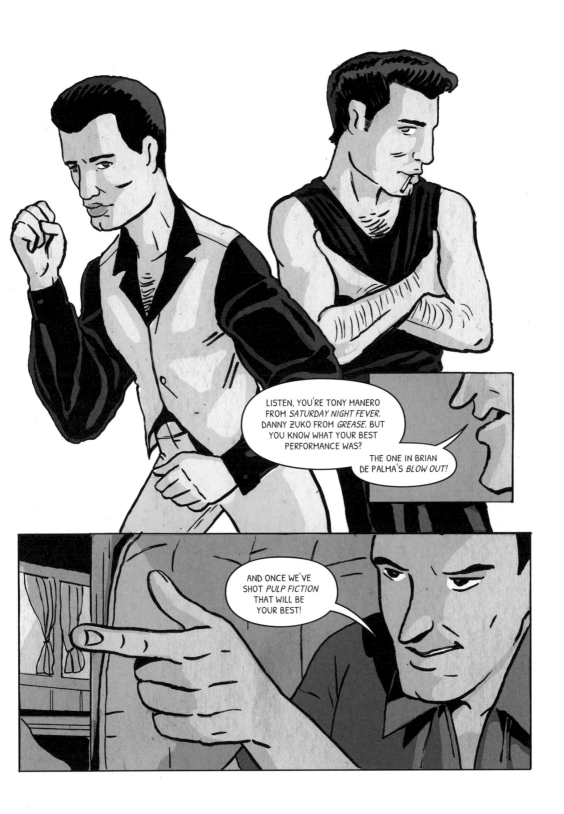

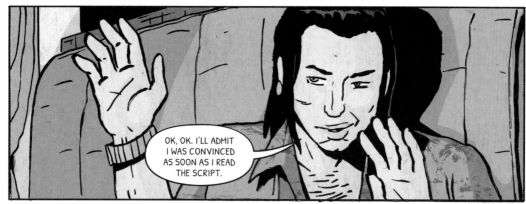

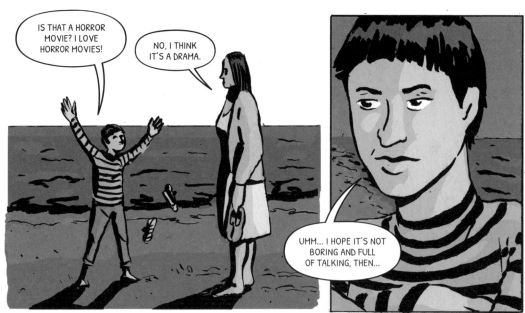

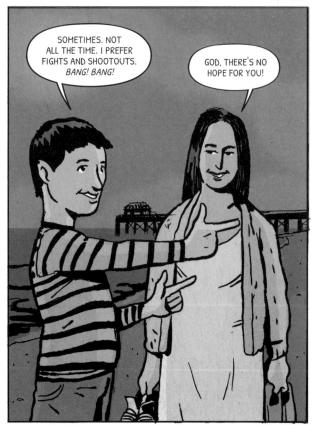

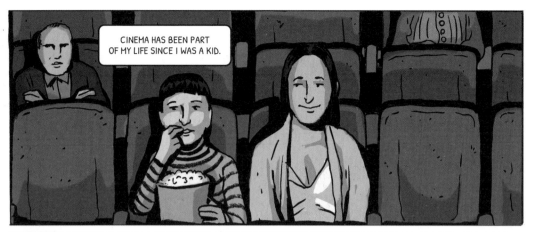

CINEMA HAS BEEN PART OF MY LIFE SINCE I WAS A KID.

MY MOM TOOK ME TO THE MOVIES ALL THE TIME; IT DIDN'T MATTER IF THE PICTURE WAS SUITABLE FOR KIDS OR NOT.

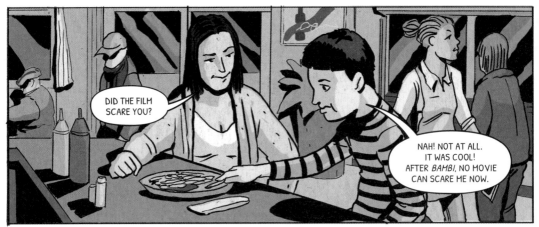

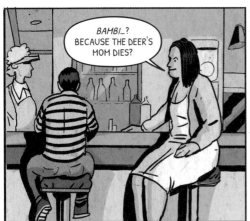

I'D BEEN TO SEE *BAMBI* WITH MY STEPDAD, AND I'D CRIED LIKE A LAMB GOING TO SLAUGHTER...

THE IDEA OF LOSING YOUR MOM WASN'T OK FOR A KID, PARTICULARLY FOR ME WHEN I'D GROWN UP JUST WITH HER.

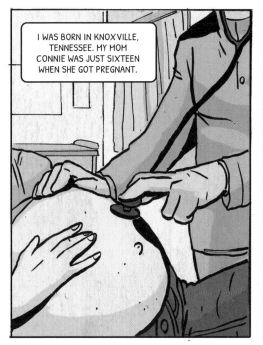

I WAS BORN IN KNOXVILLE, TENNESSEE. MY MOM CONNIE WAS JUST SIXTEEN WHEN SHE GOT PREGNANT.

MY DAD GOT OUTTA THERE PRETTY MUCH STRAIGHTAWAY. HE SHOWED UP AGAIN A LOT LATER, ONCE IT WAS TOO LATE.

NOT LONG AFTER I WAS BORN, WE MOVED TO LOS ANGELES.

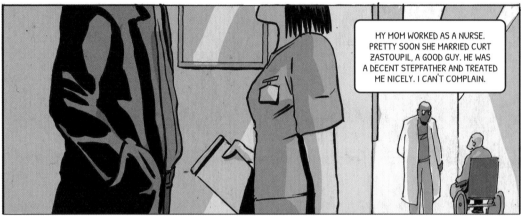

MY MOM WORKED AS A NURSE. PRETTY SOON SHE MARRIED CURT ZASTOUPIL, A GOOD GUY. HE WAS A DECENT STEPFATHER AND TREATED ME NICELY. I CAN'T COMPLAIN.

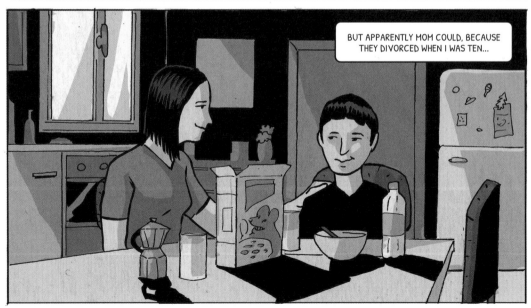

BUT APPARENTLY MOM COULD, BECAUSE THEY DIVORCED WHEN I WAS TEN...

I DIDN'T HAVE IT BAD; I DIDN'T WANT FOR ANYTHING.

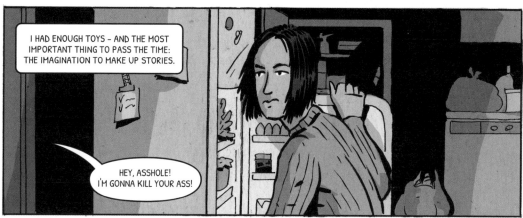

I HAD ENOUGH TOYS – AND THE MOST IMPORTANT THING TO PASS THE TIME: THE IMAGINATION TO MAKE UP STORIES.

HEY, ASSHOLE! I'M GONNA KILL YOUR ASS!

JUST YOU TRY, YOU BASTARD!

I'LL SHOW YOU WHO'S BOSS! YOU'RE TOAST!

SCHOOL WAS BORING.

TODAY WE'RE GOING TO WRITE ABOUT...

THIS IS SO BORING. CAN'T I WRITE WHAT I WANT?

QUENTIN, STOP COMPLAINING AND DO THE EXERCISE.

THINGS OUTSIDE OF SCHOOL WERE BETTER: I HAD FRIENDS TO HANG OUT WITH AND HAVE FUN.

I WAS YOUR CLASSIC AMERICAN KID.

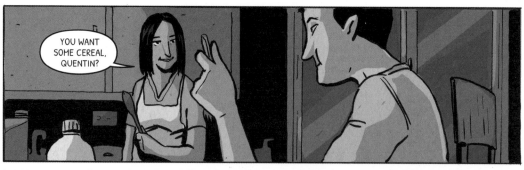

YOU WANT SOME CEREAL, QUENTIN?

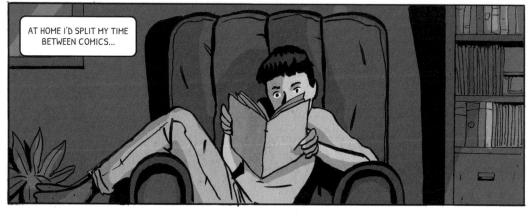

AT HOME I'D SPLIT MY TIME BETWEEN COMICS...

... TV ...

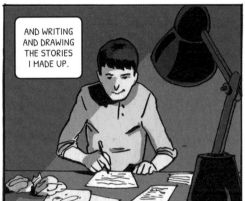

AND WRITING AND DRAWING THE STORIES I MADE UP.

1978.

TIME PASSED...

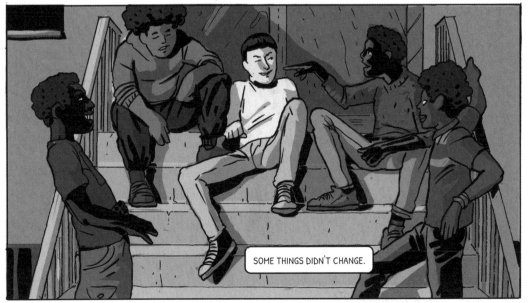

SOME THINGS DIDN'T CHANGE.

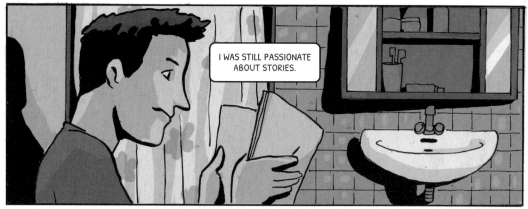

I WAS STILL PASSIONATE ABOUT STORIES.

I STILL STAYED UP MOST NIGHTS WATCHING MOVIES. IT WAS CLOSE TO BEING AN OBSESSION.

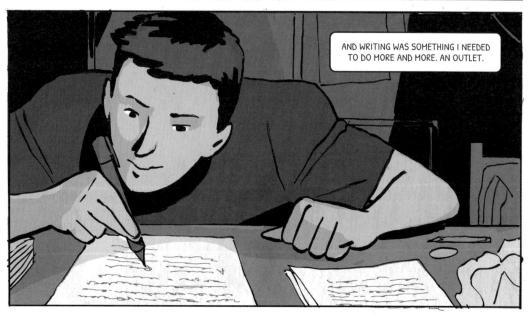

AND WRITING WAS SOMETHING I NEEDED TO DO MORE AND MORE. AN OUTLET.

AT FIFTEEN, I WAS AN ANGRY, INSOLENT KID. BUT WHO ISN'T AT THAT AGE?

THAT LOOKS COOL!

THE SWITCH

Elmore Leonard

BUT I WAS ALWAYS SHORT OF MONEY.

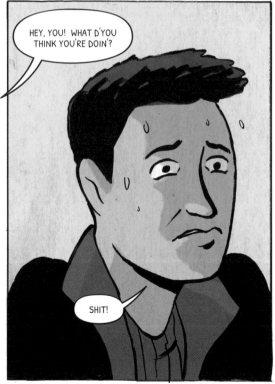

HEY, YOU! WHAT D'YOU THINK YOU'RE DOIN'?

SHIT!

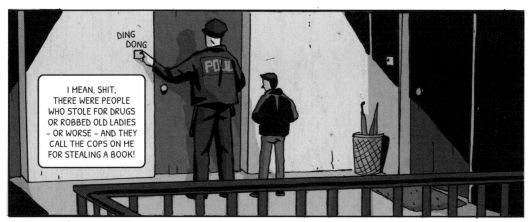

DING DONG

I MEAN, SHIT, THERE WERE PEOPLE WHO STOLE FOR DRUGS OR ROBBED OLD LADIES – OR WORSE – AND THEY CALL THE COPS ON ME FOR STEALING A BOOK!

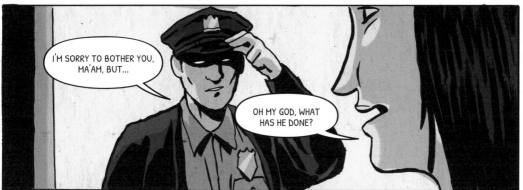

I'M SORRY TO BOTHER YOU, MA'AM, BUT...

OH MY GOD, WHAT HAS HE DONE?

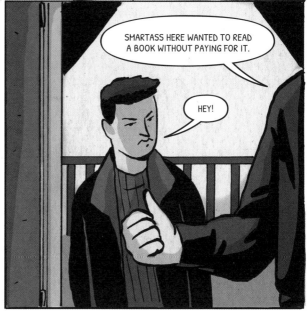

SMARTASS HERE WANTED TO READ A BOOK WITHOUT PAYING FOR IT.

HEY!

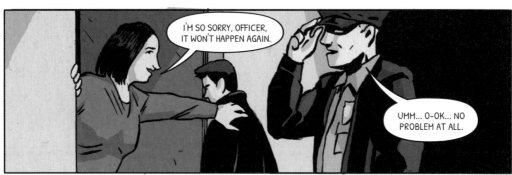

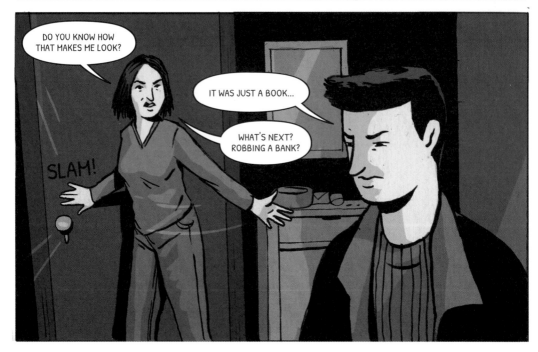

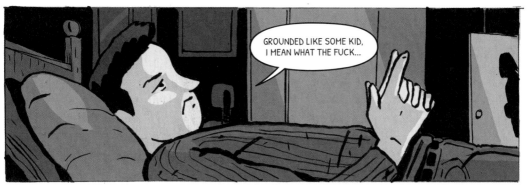

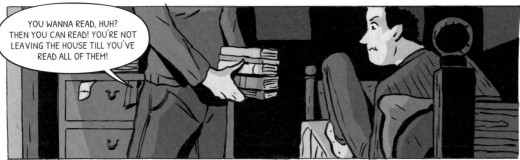

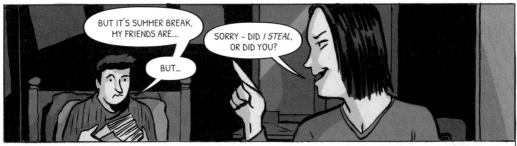

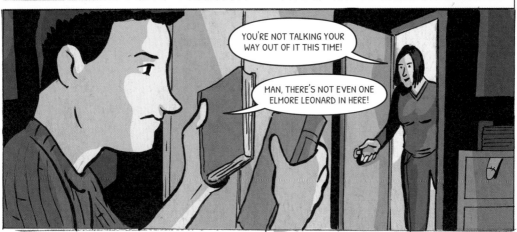

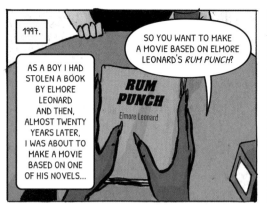

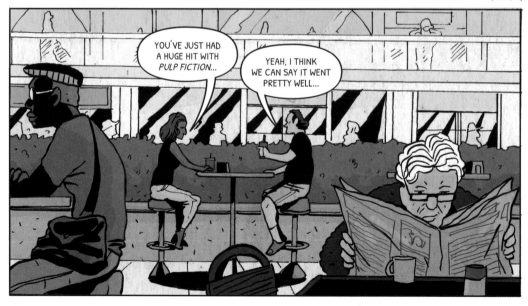

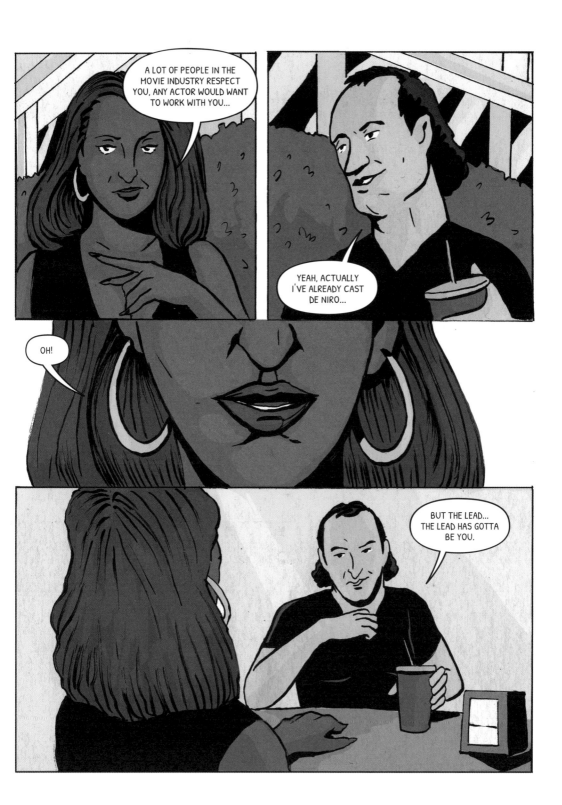

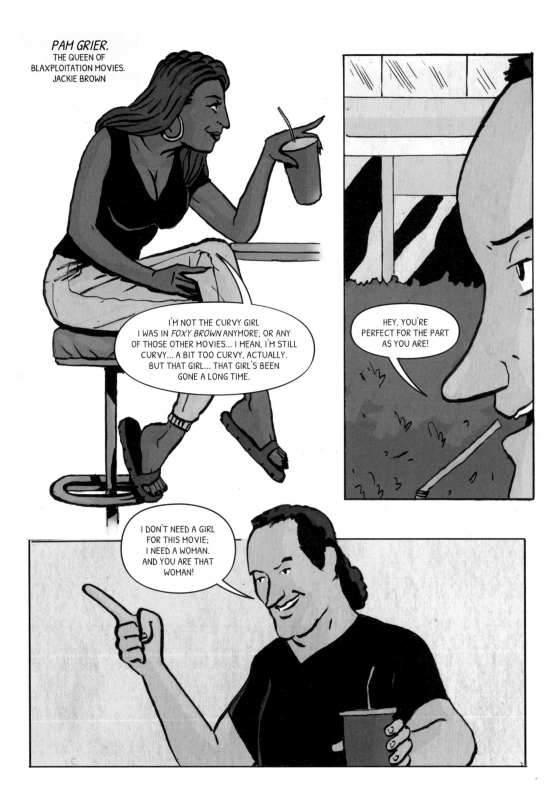

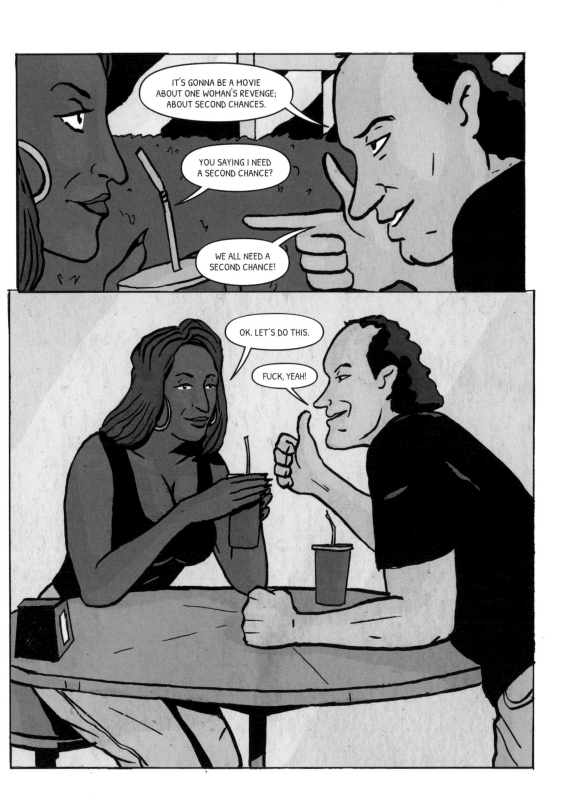

THE PEN BEHIND THE CAMERA AND THE MAN HOLDING THE PEN

IN WHICH TARANTINO HAS A FEW DRINKS WITH FELLOW DIRECTOR ROBERT RODRIGUEZ
AND THEY END UP TALKING ABOUT TARANTINO'S PASSION FOR WRITING,
A PASSION THAT MIGHT BE LESS IN-YOUR-FACE THAN HIS DIRECTING,
BUT NO LESS SUCCESSFUL.

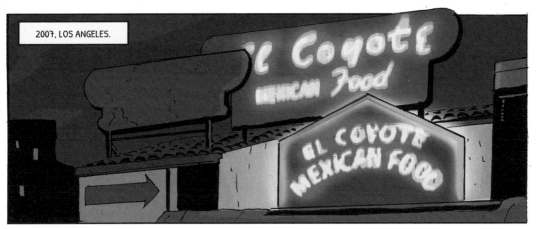

2007, LOS ANGELES.

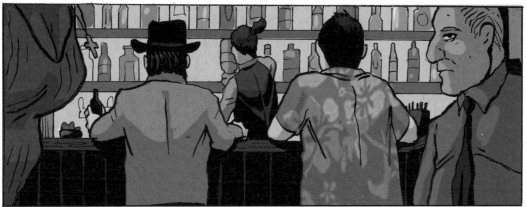

HOW 'BOUT YOU? STILL DON'T KNOW HOW TO BUY SHIRTS?

YOU'RE SUCH AN ASSHOLE.

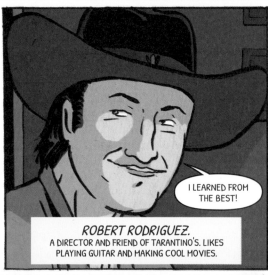

I LEARNED FROM THE BEST!

ROBERT RODRIGUEZ.
A DIRECTOR AND FRIEND OF TARANTINO'S. LIKES PLAYING GUITAR AND MAKING COOL MOVIES.

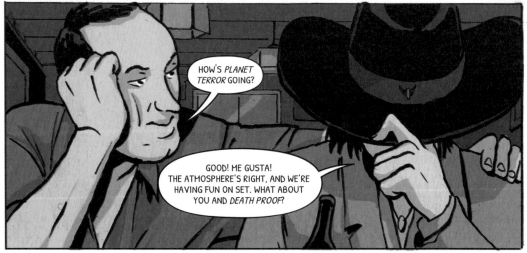

HOW'S *PLANET TERROR* GOING?

GOOD! ME GUSTA! THE ATMOSPHERE'S RIGHT, AND WE'RE HAVING FUN ON SET. WHAT ABOUT YOU AND *DEATH PROOF*?

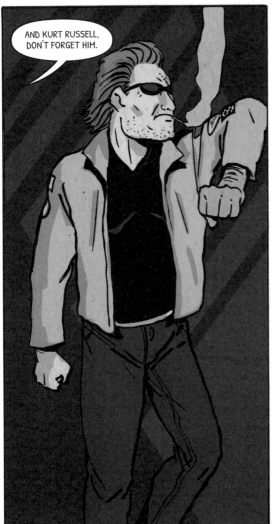

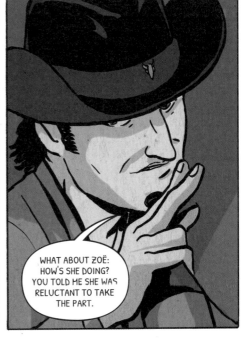

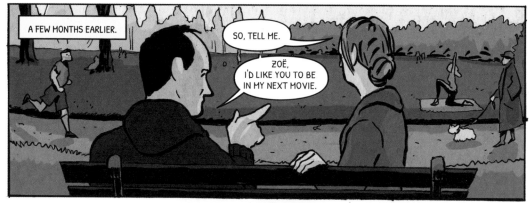

A FEW MONTHS EARLIER.

SO, TELL ME.

ZOË, I'D LIKE YOU TO BE IN MY NEXT MOVIE.

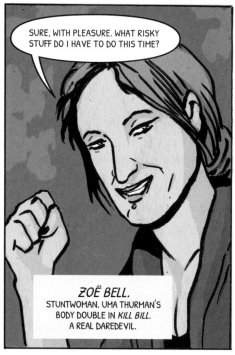

SURE, WITH PLEASURE. WHAT RISKY STUFF DO I HAVE TO DO THIS TIME?

ZOË BELL.
STUNTWOMAN. UMA THURMAN'S BODY DOUBLE IN *KILL BILL*. A REAL DAREDEVIL.

BE AN ACTRESS.

AND BE TIED TO THE HOOD OF A MOVING CAR.

WAIT A SECOND: I DON'T GET IT.

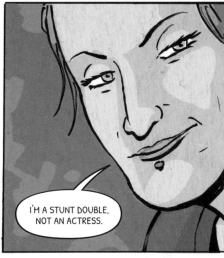

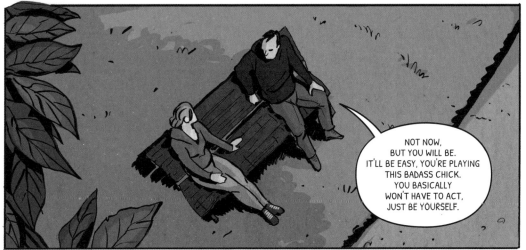

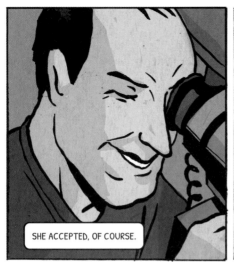

SHE ACCEPTED, OF COURSE.

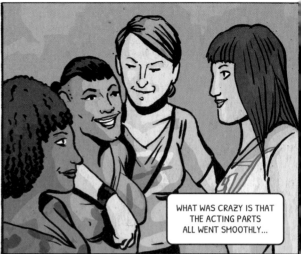

WHAT WAS CRAZY IS THAT THE ACTING PARTS ALL WENT SMOOTHLY...

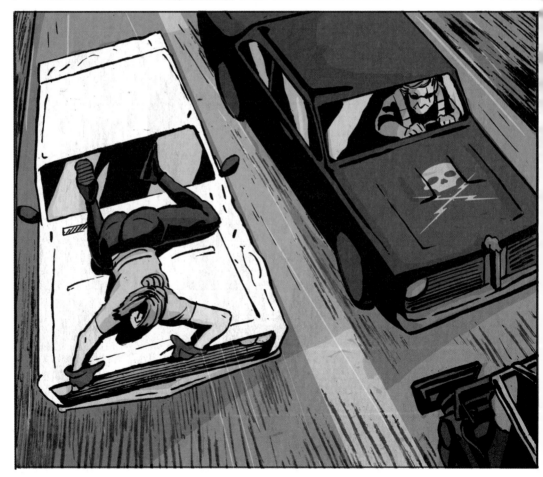

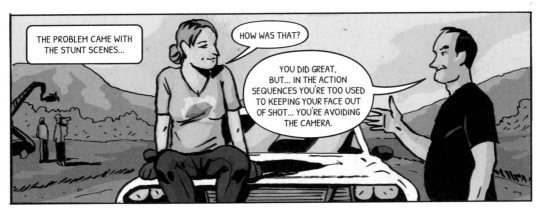

THE PROBLEM CAME WITH THE STUNT SCENES...

HOW WAS THAT?

YOU DID GREAT, BUT... IN THE ACTION SEQUENCES YOU'RE TOO USED TO KEEPING YOUR FACE OUT OF SHOT... YOU'RE AVOIDING THE CAMERA.

YOU'RE THE LEAD ACTRESS IN THESE SCENES NOW, NOT THE STUNT DOUBLE. THE AUDIENCE NEEDS TO SEE YOUR FACE WHEN YOU'RE ON THIS CAR.

AH, SHIT! I'M SO USED TO DOING IT I DIDN'T EVEN REALIZE; I JUST TURN AWAY AUTOMATICALLY!

DON'T WORRY, WE'LL DO IT AGAIN!

BUT IN THE END, COMPLETE PRO THAT SHE IS, SHE DID IT.

IT WENT WELL, BASICALLY.

ANOTHER ROUND, GUYS?

SURE!

SORRY IF I'M INTRUDING BUT... I HEARD YOU GUYS ARE STILL WORKING TOGETHER. *FROM DUSK TILL DAWN* WAS SHIT-HOT.

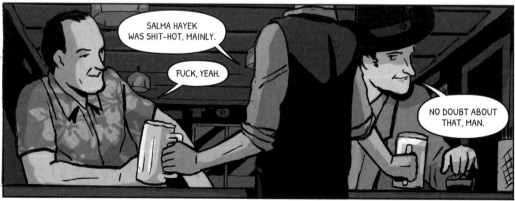

SALMA HAYEK WAS SHIT-HOT, MAINLY.

FUCK, YEAH.

NO DOUBT ABOUT THAT, MAN.

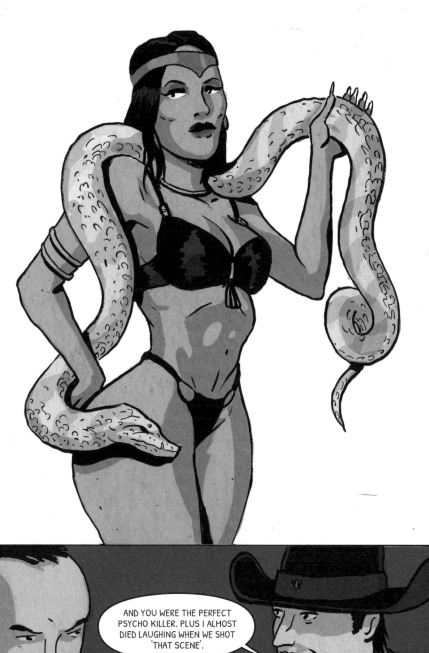

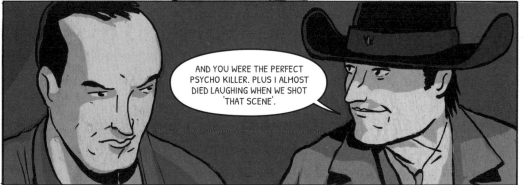

AND YOU WERE THE PERFECT PSYCHO KILLER. PLUS I ALMOST DIED LAUGHING WHEN WE SHOT 'THAT SCENE'.

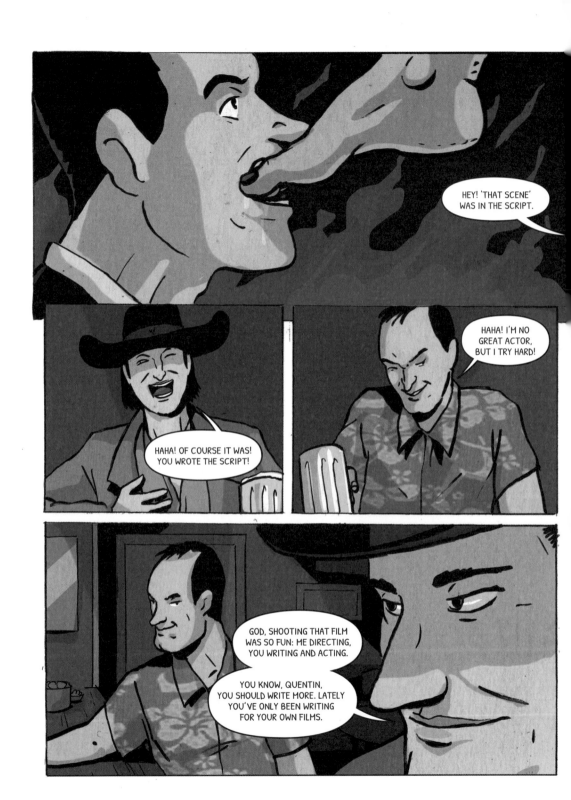

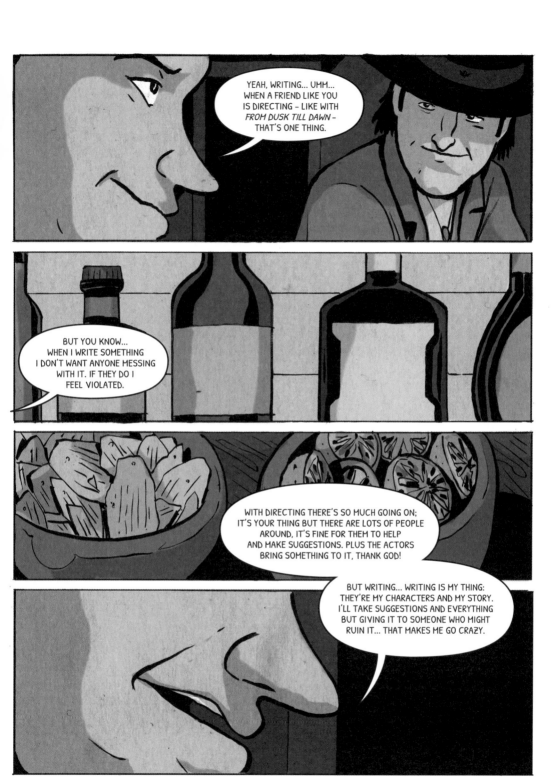

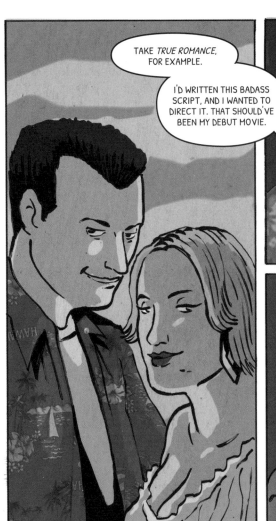

TAKE *TRUE ROMANCE*, FOR EXAMPLE.

I'D WRITTEN THIS BADASS SCRIPT, AND I WANTED TO DIRECT IT. THAT SHOULD'VE BEEN MY DEBUT MOVIE.

IT WAS AN EXPENSIVE MOVIE - OK, NOT THAT MUCH. BUT EXPENSIVE ENOUGH NOT TO GIVE IT TO SOMEONE UNKNOWN, LIKE YOU WERE AT THE TIME. THAT'S A RISK THE BIG BOSSES FIND IT HARD TO TAKE.

BUT IN THE END IT WASN'T BAD AS A SCREENWRITING DEBUT.

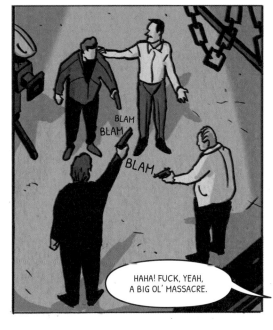

113

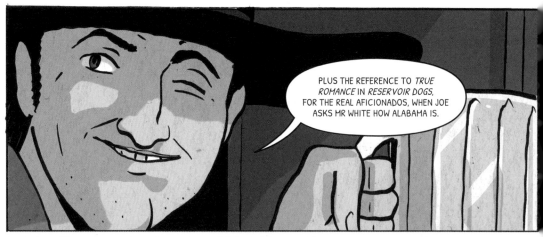

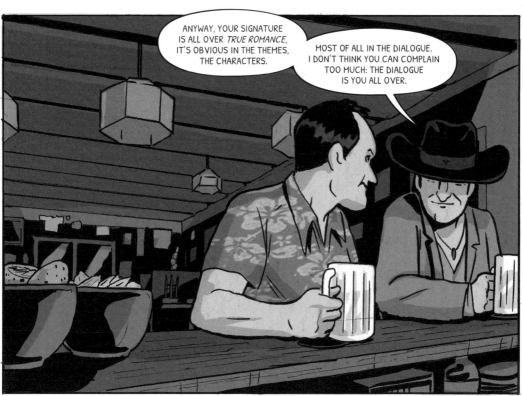

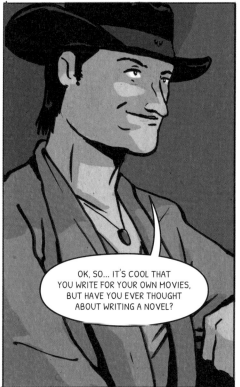

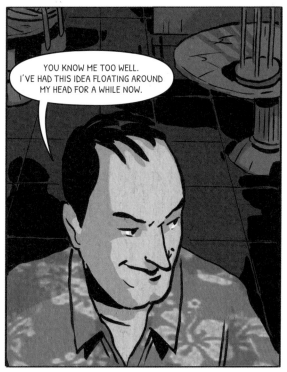

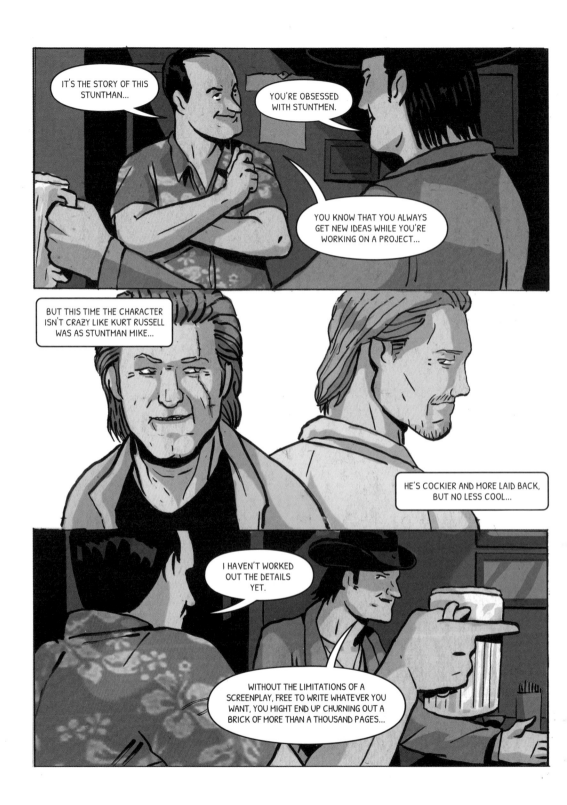

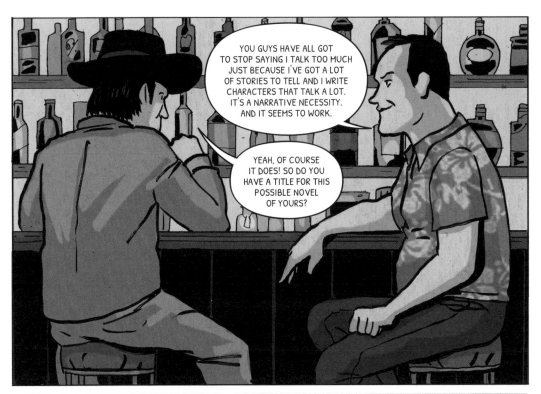

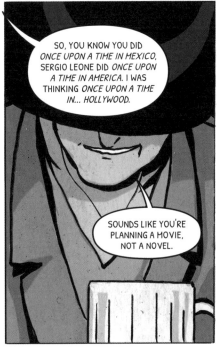

QUENTIN TARANTINO MOVIES, BOOKS AND DOCUMENTARIES

AS DIRECTOR AND SCREENWRITER:

Reservoir Dogs, 1992

Pulp Fiction, 1994 – Academy Award for Best Original Screenplay

Four Rooms – The Man from Hollywood (episode), 1995

Jackie Brown, 1997

Kill Bill: Volume 1, 2003

Kill Bill: Volume 2, 2004

Grindhouse: Death Proof, 2007

Inglourious Basterds, 2009

Django Unchained, 2012 – Academy Award for Best Original Screenplay

The Hateful Eight, 2015

Once Upon a Time in Hollywood, 2019

AS SCREENWRITER:

True Romance, directed by Tony Scott, 1993

From Dusk Till Dawn, directed by Robert Rodriguez, 1996

TELEVISION:

ER – Motherhood (season 1, episode 24), directed by Quentin Tarantino, 1995

CSI: Crime Scene Investigation – Grave Danger (season 5, episodes 24 and 25), written and directed by Quentin Tarantino, 2005

OTHER WRITING:

Quentin Tarantino, *Once Upon a Time in Hollywood*, 2021

Quentin Tarantino, *Cinema Speculation*, 2022

DOCUMENTARY:

QT8 Quentin Tarantino – The First Eight, directed by Tara Wood, 2019